Mademoiselle

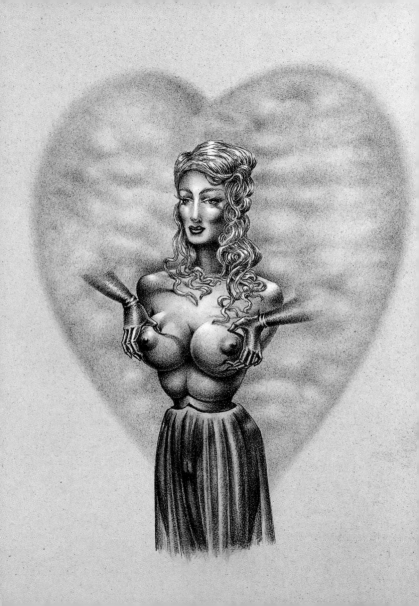

Mïrka Lugosi

Mademoiselle

texts by

Marie-Laure Dagoit

Last Gasp

"The walls of paradise are in the heart of woman;
it's the candy that God sucks on."
Xavier Forneret

Forgetting the games
the quarrels
the sorrows
the laughing eyes
of vair.
I flaunt myself unkempt
hair undone
hennin
gold chains fixed to the collar
back arched
belly projected
round leg
small foot
broad gleaming forehead
dimpled chin
scarlet lips
a wart masked by a moon-shaped sequin

For years I've dwelt in this house.
I'm known as an easy piece on the street
as a back-alley roamer
as the terrifying shadow of crows.
I live like the wild beasts in the woods
the dog runs about blindly to please my whim.
I watch the great ceiling riddled with pink stars
like crushed blackberries.
Mademoiselle calls me her "little queen".
Everyone strokes me but within certain limits
for after all I'm married to Monsieur.

Come morning, someone finds me standing in the doorway
with the attentive face of one observing some spectacle
I trust the secret of my solitary meditations to no one
the blush that modesty marks on the butts of virgins
and wives.
I lean against the window
watch the bitches flagellate themselves far off
a blow from a whip
(with the sound of a scythe being sharpened)

makes them bend their backs
drop shoulders
and head.
A door opens
I shiver within a hiss of polished steel
legs stiff
back curved.

The good townspeople talk to me as though I were a marquise
love me as one of their own.
Hand on hip
still and serious
I watch them
the ingenue.
The oldest ones get ecstatic
offering their buttocks to my lips
cheeks big and open like warm hands.
The air smells like chicken fat
cool wine
I offer myself for a louis d'or.

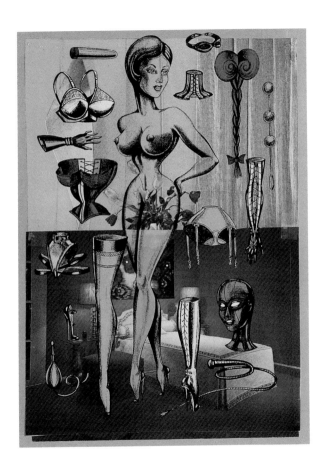

Oubliant les jeux/les querelles/les chagrins/
les yeux vairs/riants. Je m'exhibe négligée/
décoiffée/hennin/chaînes d'or attachées au col/
reins cambrés/ventre saillant/la jambe ronde/
le pied petit/le front fenestric/le menton
fourchelé/les lèvres vermeillettes/une verrue
masquée par une mouche taillée en lune.

Voilà des années que j'occupe cette maison.
On me connaît autant qu'un morceau de trottoir/
qu'une ruelle/que l'ombre terrifiante des corbeaux.
Je vis comme les bêtes des bois/le chien court
pour mon plaisir avec des gestes d'aveugle.
Je regarde le grand plafond criblé d'étoiles roses
comme de la mûre écrasée.
Mademoiselle m'appelle sa « petite reine ».
On me caresse un peu mais trop fort tout de même
parce que je suis la femme de Monsieur.

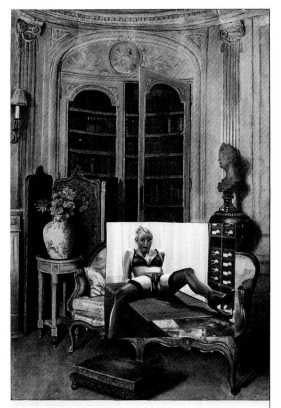

LE SALON DE M^{me} BARTET PEINT PAR ELLE-MÊME

Le matin, il arrive qu'on me trouve debout
dans l'entrée/droite avec le visage attentif
d'une personne qui observe quelque spectacle.
Je ne confie à personne le secret de mes
méditations solitaires/le rouge que la pudeur
met au cul des vierges/des épouses.
Je m'appuie contre la fenêtre/regarde au loin
les garces se flageller/un coup de fouet
(avec un bruit de faux qu'on aiguise)
leur fait plier les reins/baisser les épaules/la tête.
Une porte s'ouvre/je grelotte dans un murmure
d'acier poli/les jambes raides/le dos rond.

Les bonnes gens du village me parlent comme
à une marquise/m'aiment comme une des leurs.
Une main posée sur la hanche/immobile et
grave/je les regarde/ingénue.
Les plus vieux s'exaltent/offrent à mes lèvres
leurs fesses/grandes ouvertes comme des mains
chaleureuses.
L'air sent la graisse de poule/le vin frais/
je m'offre pour un louis d'or.

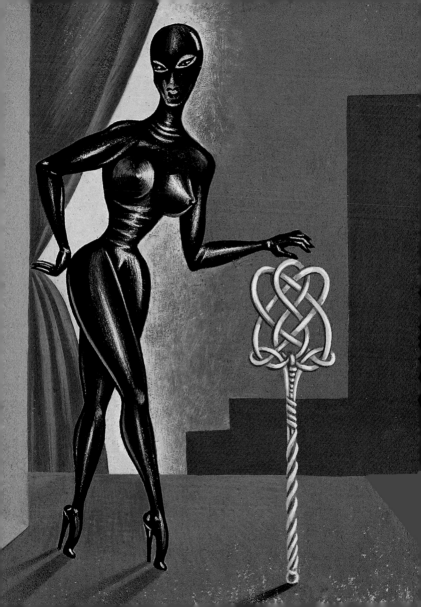

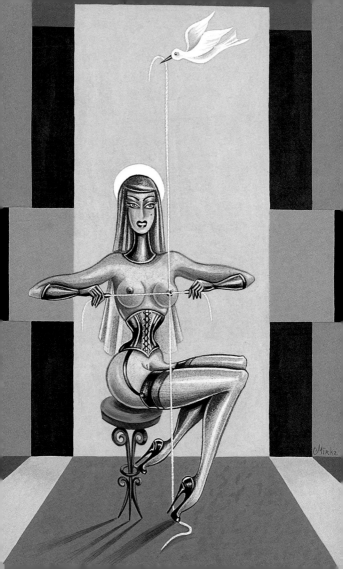

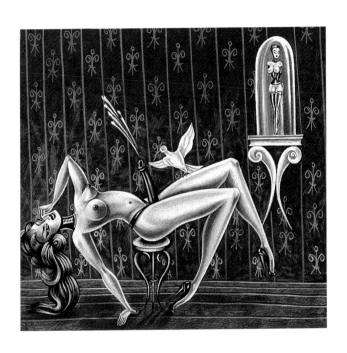

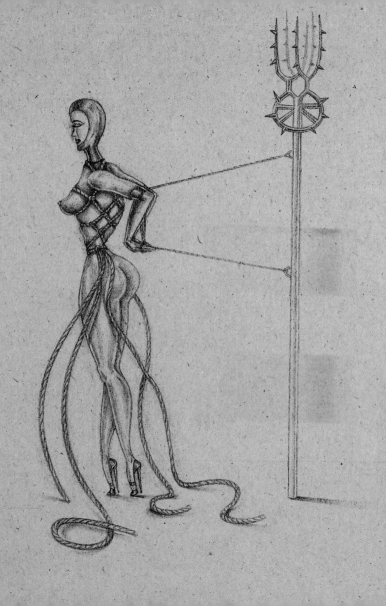

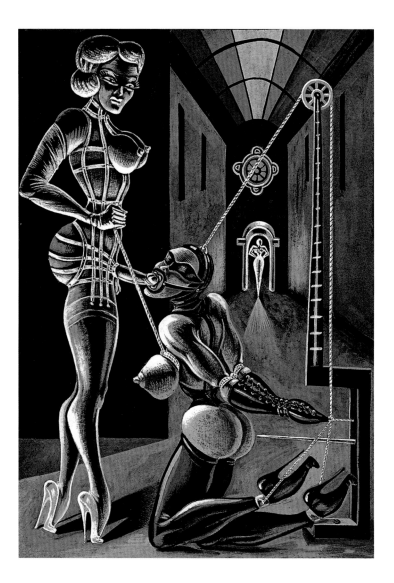

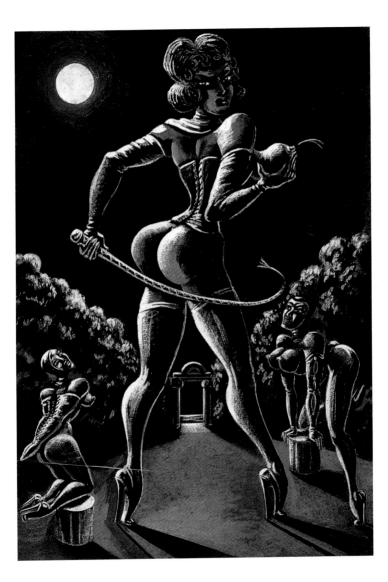

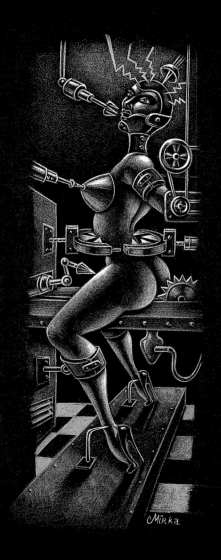

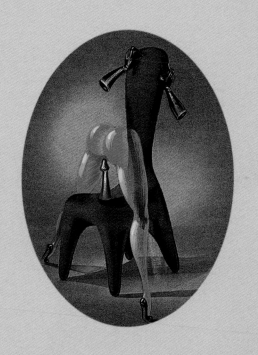

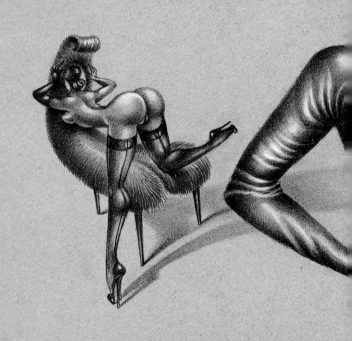

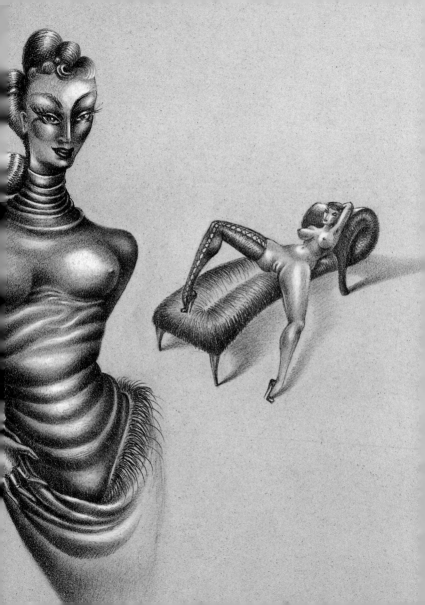

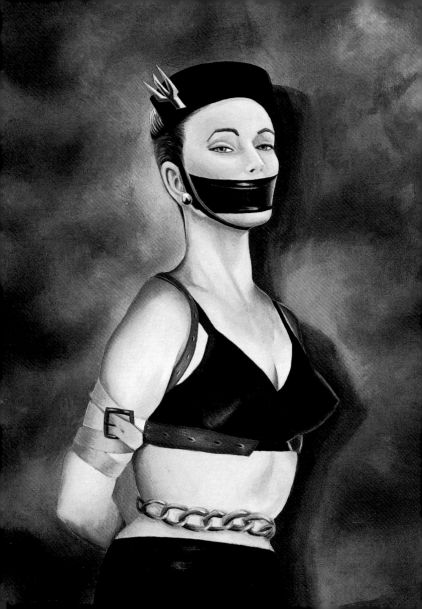

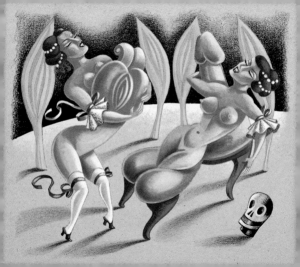

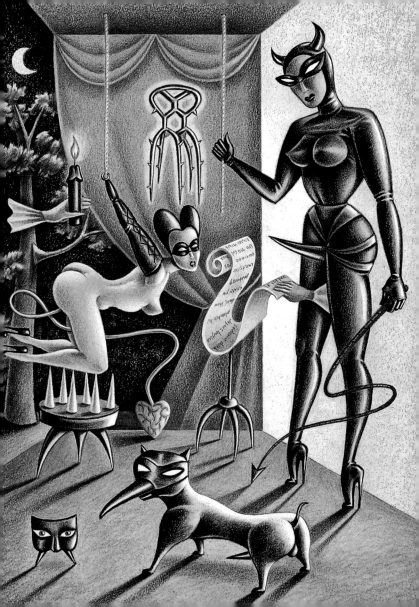

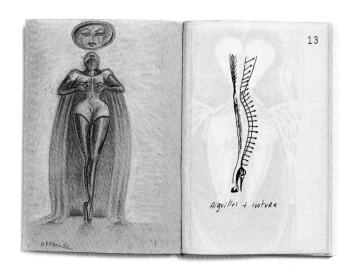

OFFRande

13

Aiguilles + couture

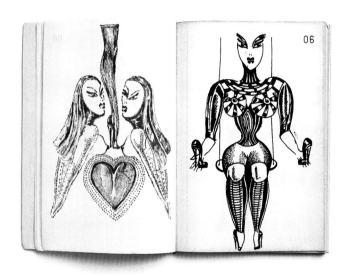

(Two bitches look for a place
to get off.)
Hedgehog ashes
vinegar
mirror
egg whites
insect wings
dragonfly
Spanish fly
precious substances
coatings
honey
hemlock juice
ant blood
pissar
pissar.
The smile becomes languid
painted with lies
full mouth
giddy
fluttery little fool
These girls
these whores
these streetwalkers
these courtesans
eye circled with stribnite
edged with kohl

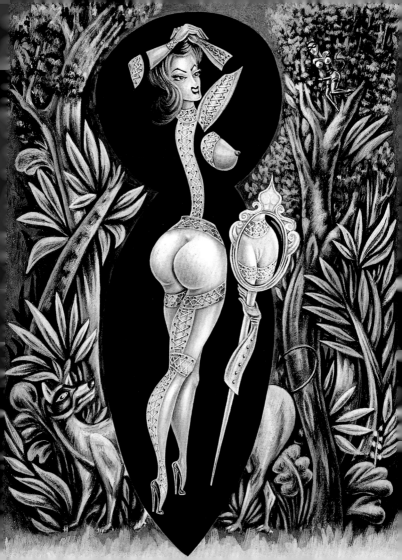

breasts rouged with orcanette

diaphanous eyelash

held in honor every day, are lethal drugs.

My mouth in trompe-l'oeil smells like sulphur

salt

fava flower

chalk

pride.

A candlestick tints my ass where a whip out of control

cracks from its heavy leather grip.

Mademoiselle

devil's amazon

painted garish saffron

charcoal eye

red mouth

grape

Mademoiselle

grape mouth

crimson cheeks

pretty and swollen

Mademoiselle

crimson fleshy lips

charcoal eye

Mademoiselle

devil's amazon

a dildo of unknown form.

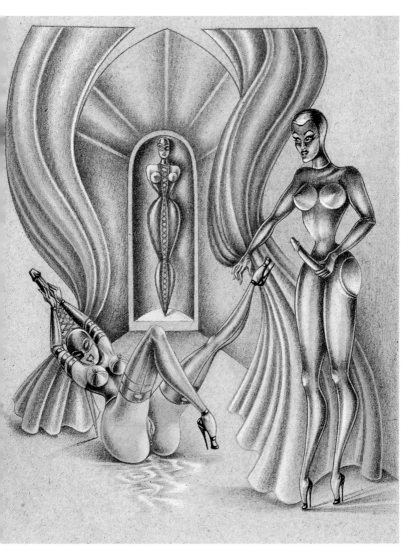

(Deux garces cherchent un endroit pour se faire
jouir.) Cendres de hérisson / vinaigre / miroir /
blancs d'œuf / ailes de mouches / libellule /
cantharide / matière noble / enduits / miel /
suc de ciguë / sang de fourmi / pissar / pissar.
Le sourire se fait langoureux / peint par le
mensonge / la bouche épaisse / gaie / foliette.
Ces filles / ces putes / ces traînées / ces courtisanes /
l'œil cerné d'antimoine / passé au khôl / les seins
rougis d'orcanette / la paupière diaphane /
à l'honneur tous les jours, sont drogues mortelles.
Ma bouche en trompe-l'œil sent le soufre /
le sel / la fleur de fève / la craie / l'orgueil.
Un bougeoir teinte mon cul où un fouet désemparé
cogne de son lourd bras de cuir.
Mademoiselle / amazone du diable / peinturlurée
au safran / l'œil charbonneux / la bouche rouge /
raisin / Mademoiselle / la bouche raisin /
les joues carminées / à enflure mignonne /
Mademoiselle / les lèvres incarnates / l'œil
charbonneux / Mademoiselle / amazone du diable /
un godemichet d'une forme inconnue.

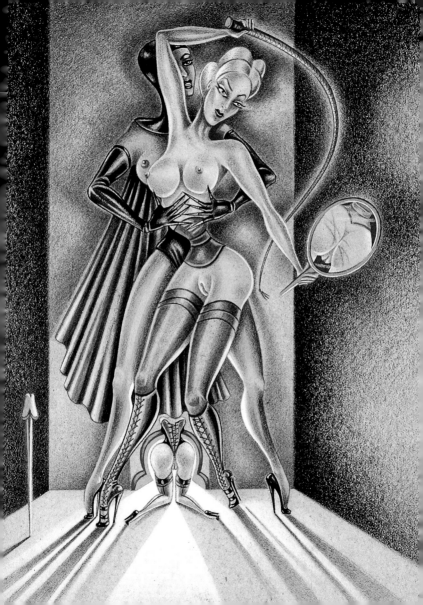

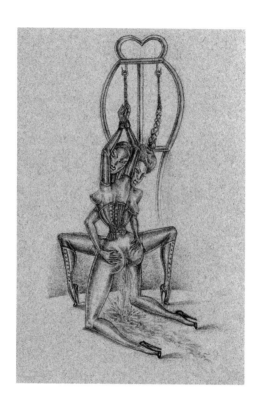

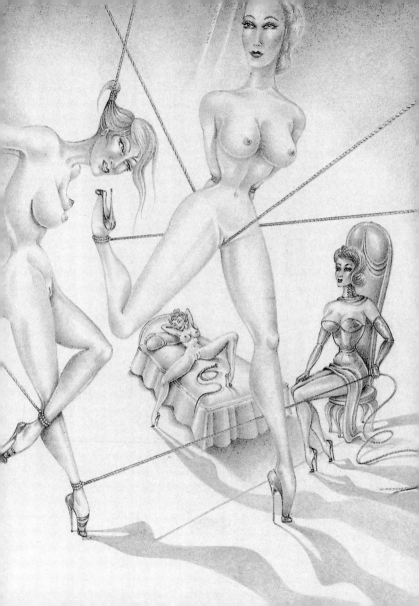

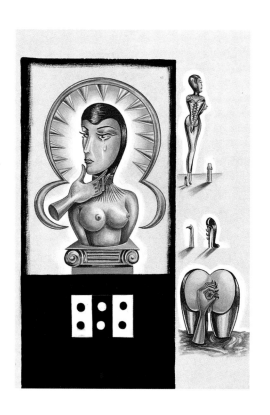

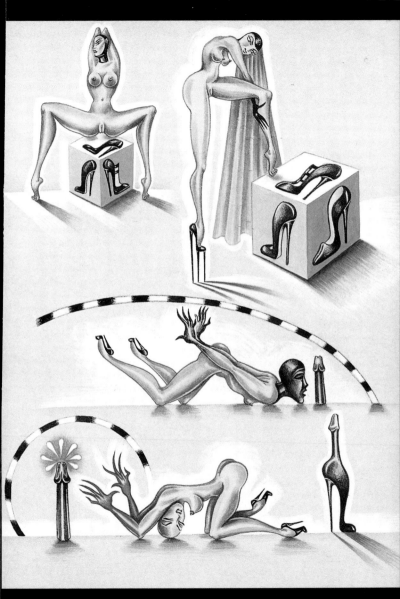

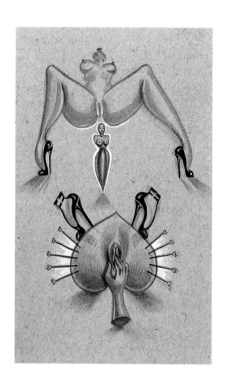

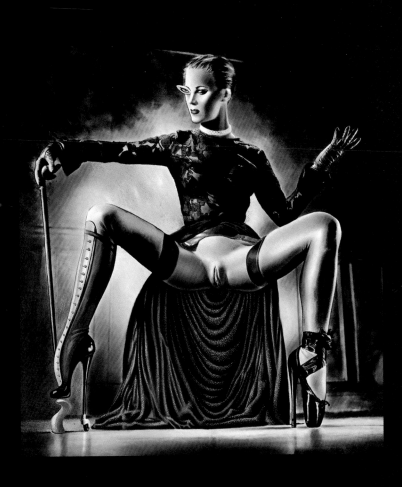

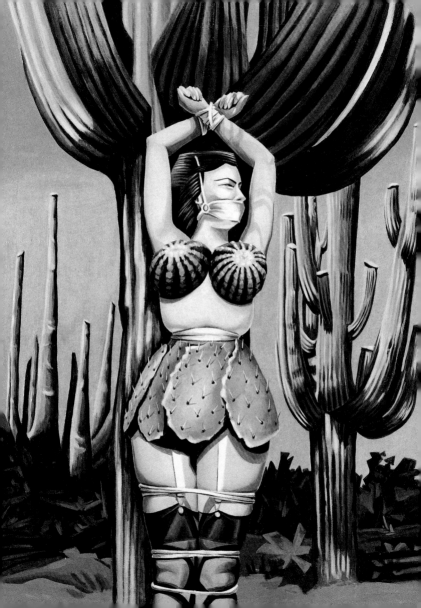

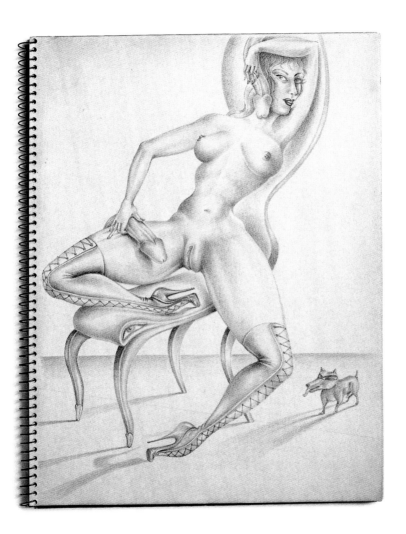

41

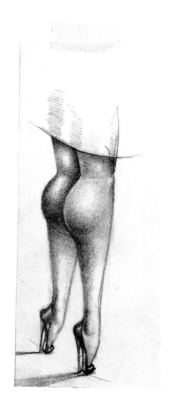

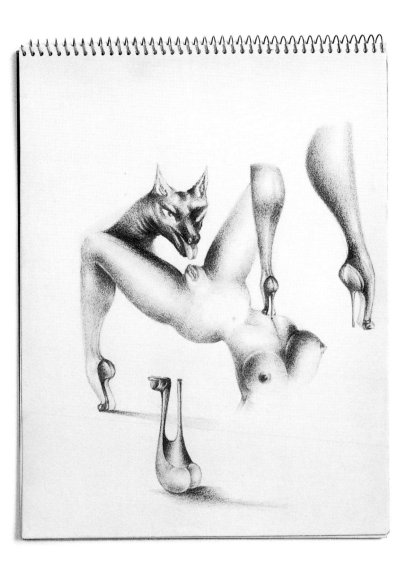

43

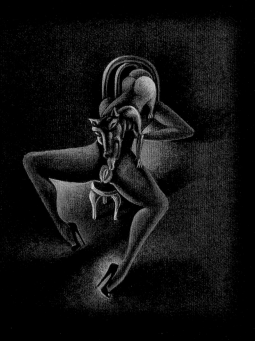

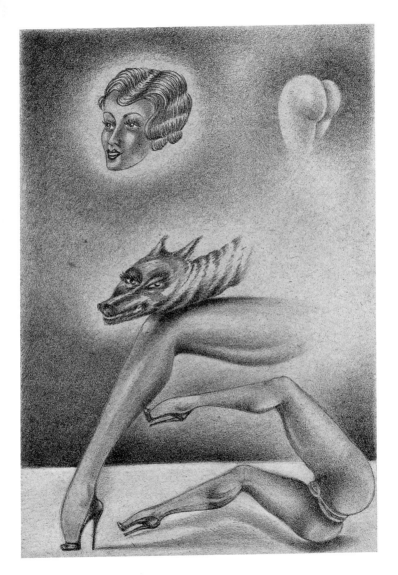

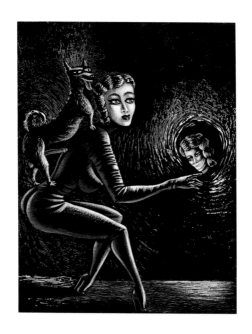

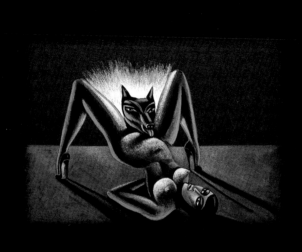

Carco began to inspect
my thighs with the help of a probing wand.
Then he went to my breasts
where countless hands
sometimes abound.
Here and there, my eyes let their
fruit fall, black
thick.
Outside,
you can hear the hunters' gunshots.

...

Carco a commencé à inspecter
mes cuisses à l'aide d'un bâton.
Il est allé ensuite vers mes seins
où foisonnent parfois
de nombreuses mains.
Çà et là, mes yeux laissent tomber
leur fruit, noir/épais.
Dehors,
on entend le coup de fusil des chasseurs.

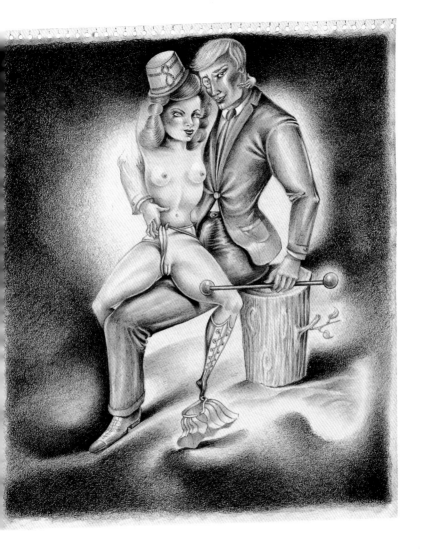

waters

 obstruct

 deep

 giant

 limbs

WITH BEST
NEW YEAR
WISHES

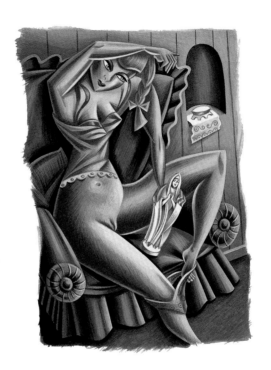

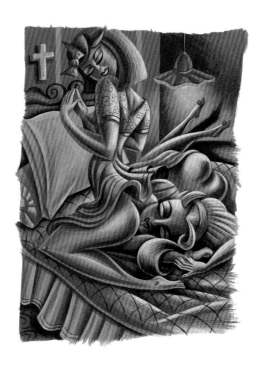

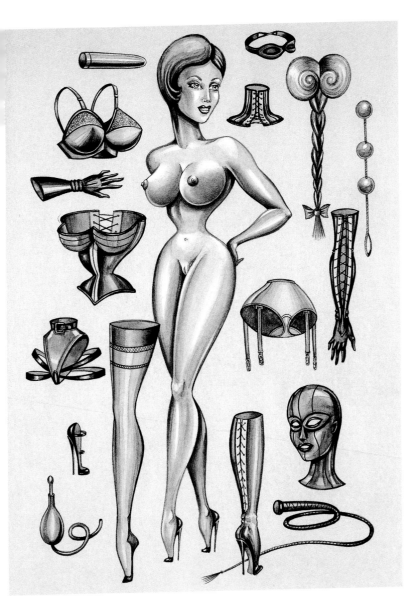

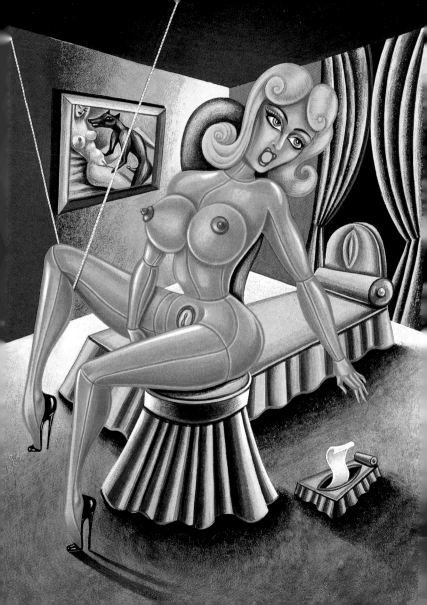

Come evening, she leaves drunk
staggering
dazed
aqualine nose
celestial breast
tapered fingers
rubbed with coral
cuttlefish bone
cinnamon
hair sprinkled with purple dust
high cheekbones
colored like red crepe paper
raspy throat
painted lips
chapped
a white deposit in the corner of the mouth
ash-white
plaster
ornatus vanus.
Mademoiselle, a doll
my doll
our doll.

Au soir, elle part ivre / chancelante / éblouie / le nez traitis / le sein céleste / les doigts effilés / frottés de corail / d'os de seiche / de canelle / le cheveu couvert de poudre violette / la pommette haute / passée au rouge crépon / la gorge râpeuse / les lèvres peintes / gercées / au coin de la bouche un dépôt blanc / blanc de céruse / plâtre / ornatus vanus. Mademoiselle, une poupée / ma poupée / notre poupée.

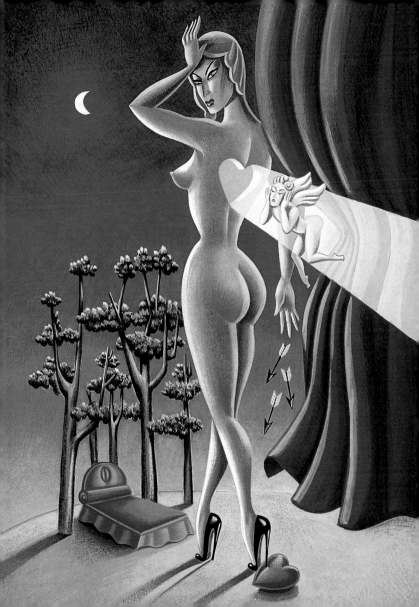

Mirka dedicates this book to Gilles

Mademoiselle thanks from the bottom of her heart

Marie Laure Dagoit, the girl «derrièrelasalledebain»

Luc-Marie Bouët & Stéphane Nappez
for their precious participation,

as well as mister Alain K.S, mister Alexandre D.,
mister Erick G., mister Jean-Luc F., mister Jean Pierre F.,
mister John W. and Zorin/Blitzo Schwartzo,

and her sweet damsels Brigitte, Claudia, Jeannie, Jeannine,
Jocelyne and Rita.

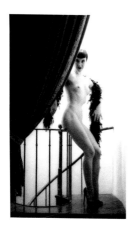

Mürka is a painter of pictures.
She enjoys painting dogs very much
but mostly ladies.
Ladies with dogs and other ladies-in waiting,
exposing themselves like good time girls.
She often poses naked
for her friend Gilles who is a photographer.
She paints also on Gilles' photographs.
She often paints very small pictures
because her whole world fits on the kitchen table.
She shoots all this with her small camera,
things in her life and then herself.
She calls this "the psychoanalysis of the picture".

She also likes to show her legs
and to paint her mouth red.

Four thousand copies of "Mademoiselle"
were printed one fine day in February 2002
on the printing presses of Le Govic, in Nantes, France,
on behalf of Last Gasp of San Francisco.

© Mirka Lugosi for the pictures.

© Marie-Laure Dagoit for the texts (except page 63).

The English translation is by Phillip J. Guilbeau.

The layout and direction are by Gilles Berquet,
so is the photography.

Luc-Marie Bouët helped in technical matters.

Films were shot by Le Govic.

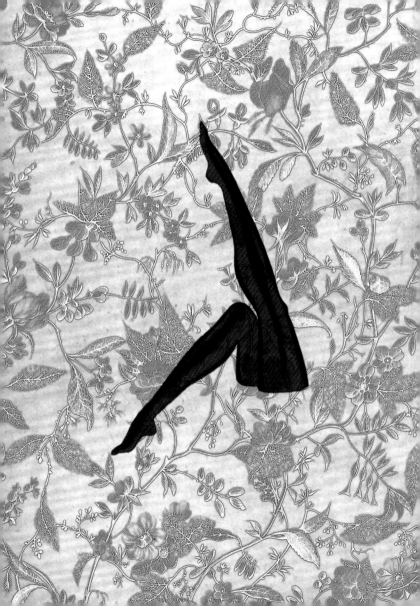